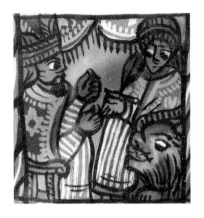

The Ethiopian Legend of

SOLOMON AND SHEBA

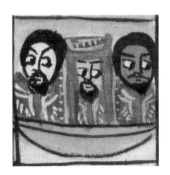

Sarah Norodom, Hanna Kim, and Andres Reyes

with translations by Meseret Oldjira

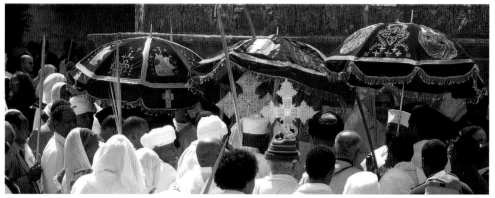

1. Palm Sunday procession of the Ethiopian Orthodox Church on the roof of the Church of the Holy Sepulchre, Jerusalem.

The Ethiopian Legend of Solomon and the Queen of Sheba

In November 1984, the distinguished Ethiopian academic, medical doctor, and political reformer Professor Asrat Woldeyes gave a fine painted goatskin to Groton School in Groton, Massachusetts (p. 71). Within the context of traditional Ethiopian art of the twentieth century, this was a remarkable and unusual work, and, in the early 1980s, it was remarkable and unusual too to place it within the setting of a New England boarding school. The gift was Professor Asrat's way of thanking the School for its part in the education of his son, then in the Fifth Form. Political necessity meant that he would only visit Groton that day in 1984, but he followed his son's progress closely, as long handwritten letters from Professor Asrat to the School attest.

Professor Asrat's own education began in Addis Ababa, capital of Ethiopia, where he was born on 12 June 1928. He later attended Victoria College in Alexandria, Egypt. After training in the medical faculty of the University of Edinburgh, he returned to Ethiopia to become one of the founders of the medical school at the University of Addis Ababa and personal physician to Haile Selassie, Emperor of Ethiopia from 1930 until 1974. After the death of Haile Selassie in 1975, he continued to serve as professor and dean at the University of Addis Ababa, remaining active in Ethiopian politics and advocating non-violent means to advance social reform. He was imprisoned for his political activities in 1994. He was allowed to leave for Europe and America in 1998 to receive medical treatment but died in hospital in Pennsylvania on 14 May 1999.

The painting Professor Asrat gave the School depicts, in 25 scenes, the legendary encounter between Solomon (King of Israel in the tenth century BC) and the Queen of Sheba, known as "Makedda" in the Ethiopian tradition. Sheba or Saba was a kingdom of southern Arabia, in modern-day Yemen, with extensive influence in northern Ethiopia, where Sabaic-speaking settlers are attested in the seventh and sixth centuries

2. Garima Gospels, empty frame from Abba Garima I and a saint from Abba Garima III.

BC or even earlier. In the second/third and mostly in the sixth century AD, the Aksumite kingdom (based in Aksum) was involved in Yemen. In legend, the Queen of Sheba became associated with Ethiopia and was claimed as one of its early rulers.

From 1984, the Groton School painting was displayed in its School House, inside the Head Master's office. In 2003, it was transferred to the Greek and Latin wing of the building to hang above the blackboard of one of the classrooms, where many boys and girls have become acquainted with it and continue to do so. This book explains what makes this work of art distinctive and publishes it alongside another painting by the same artist, Janbaru Wandemmu, which presents more scenes from the legend of Solomon and the Queen of Sheba (p. 13).

Solomon and the Queen of Sheba in the Biblical, Jewish, and Islamic Traditions

As a deacon of the Ethiopian Orthodox Church, Professor Asrat would have been especially knowledgeable about the story of King Solomon and the Queen of Sheba. The basic tale is best known from the Biblical account in 1 Kings 10: 1–13 (composed by the sixth century BC), in which the Queen is not named. Having heard of Solomon's reputation as a holy and wise ruler, she travelled to Jerusalem "to test him with

enigmatic questions". Solomon answered all that she asked, and "not one of them was too hard for the King to answer". Awestruck, the Queen presented Solomon with gold, spices, and precious stones. He, in turn, gave her "whatever she desired and asked for, in addition to all that he gave her of his royal bounty", before she went home.

This account does not explain what riddles she posed or how she tested him, but later traditions added details. For example, the Jewish text called the *Targum Sheni* (dated between AD 500 and 1000), which elaborated on the Book of Esther, introduced magical elements. In this telling, a talking bird warned the Queen that Solomon was threatening to invade her kingdom unless she traveled to Jerusalem. Arriving there, she found Solomon in the middle of what looked like a pool of water, but was actually a mirror. Instinctively lifting the hem of her dress, the Queen revealed her legs to Solomon, which he declared "hairy". Ignoring the comment, the Queen tested Solomon by setting him three riddles to answer. The quality of the riddling may be gauged from the following which the Queen is said to have asked: "[Like] dust it comes forth from the earth: / It is nourished from the dust of the earth: / It is poured out like water: / It illumines the house" (cited by Silberman in Pritchard 1974). Solomon correctly answered, "Naphtha", an oil flowing from the ground like water and used to light lamps.

The Koran has a similar account in the *Sura of the Ant* (Sura 27.15–45) on which later Islamic authors expanded. In one elaboration, Solomon ordered demons to epilate the legs of the Queen, who is named "Bilqis". The Islamic authors also increased the number of riddles the Queen propounded. She asked, for example, "Where is there flowing water that is neither on earth nor in the sky", to which Solomon gave the inspired and unexpected response, "The sweat of a horse" (cited by Watt in Pritchard 1974).

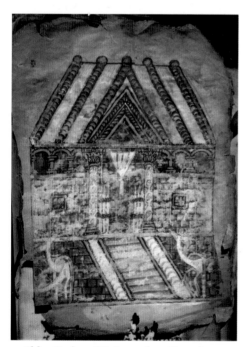

3. Abba Garima III, Jerusalem Temple image.

The Ethiopian Legend

Within the Christian world, the Ethiopian book known as the *Kebra Nagast* or "Glory of Kings", a foundational text for the Christian Church of Ethiopia, contains the most elaborate re-telling of the legend of Solomon and the Queen of Sheba. It is written in Ge'ez, which is still the liturgical language of the Ethiopian and Eritrean Orthodox Churches. Although

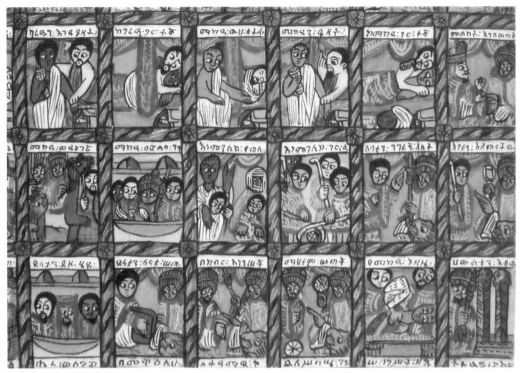

4. Detail of panels of the legend of Solomon and Sheba, painted by Janbaru Wandemmu.

the *Kebra Nagast* had taken its present-day form by the fourteenth century AD, it probably includes material from at least the sixth century AD and reflects an early oral tradition.

The Aksumite kingdom, which covered much of the area of modern Ethiopia and Eritrea, flourished from the first to the seventh centuries AD, when Christianity was spreading across the Mediterranean world. With its capital in Aksum, it became wealthy from trading products such as ivory with the Roman (and later Byzantine) empire in the Mediterranean and further east. Because of this contact, the Aksumite monarchy became Christian, adding crosses to its coinage as a sign of this *ca.* AD 360. Over the next two centuries, Christianity spread to the countryside.

The Aksumite kingdom had the resources and technical knowledge to build the stelai at Aksum (fig. 9) and produce illuminated gospel books, such as the Garima Gospels (figs. 2–3). The Garima Gospels (ca. AD 480–650) are the earliest surviving examples of a tradition of painting which continues in Ethiopia to the present day. Illustrating the *Kebra Negast* is a recent result of that tradition. The Groton School painting shows a version of the legend of Solomon and Sheba similar to that outlined in the *Kebra Nagast*, which relates the origins of the Ethiopian Church to the removal of the Ark of the Covenant (the chest containing the stone tablets inscribed with the Ten Commandments) from Jerusalem to Ethiopia by Menilek, Solomon's son by the Queen.

The story of King Solomon, Queen Makedda, and Menilek is told as follows in chapters 21 to 63 (of the 117 chapters) of the *Kebra Nagast*:

Makedda, having heard of Solomon's wealth and wisdom from the merchant Tamrin, desired to judge his reputation for herself. She travelled to Jerusalem and was so impressed by Solomon that she promised all her kingdom would henceforth worship the god of Israel. But before she returned home, Solomon proposed at a banquet that she stay with him. Makedda refused and made the King swear that he would not "take her by force". Solomon agreed he would not, but warned that he would consider himself free to do so if she took any of his possessions.

But Solomon had deliberately made the banquet food very spicy. Waking in the middle of the night because she wanted a drink of water, Makedda discovered that the only water available was beside Solomon's bed. So she went into his room and drank. By this act, Solomon considered she had, in fact, taken one of his possessions. That evening, Makedda conceived a son by Solomon, and, nine months later, after the Queen had returned to Ethiopia, Menilek was born.

When Menilek grew up, Makedda revealed to him that Solomon was his father. She entrusted him with a ring which Solomon had given her, so that he could take it to Jerusalem as a sign to the King that Menilek was his offspring. Solomon acknowledged him as his son, but rather than stay in Jerusalem, Menilek decided to return to Ethiopia. Solomon allowed him to leave, on condition that Ethiopia became a Jewish colony. But without his father's knowledge, Menilek took the Ark of the Covenant, with the tablets of the Ten Commandments in it from the Temple in Jerusalem. Having discovered its disappearance, Solomon pursued Menilek, but his attempt to retrieve the Ark was futile.

Solomon concluded that the Ark could only have been removed by God's providence and that divine will had allowed its transfer into Menilek's care. Ethiopia, in other words, was the new Jerusalem. According to tradition, the Ark resides today in a special chapel beside the Cathedral of Mary of Zion (Maryam Tsion) in Aksum.

Other versions of the legend, written and oral, began the story by explaining how Makedda had come to rule. One account held that her father, Agabo, had killed the snake dragon, Arwe, who was terrorizing the land. He fed it a goat filled with poison, and in gratitude, the people accepted him as ruler, to be succeeded by Makedda.

These variants, especially those in the oral tradition, appear as details in the paintings, where Solomon is also seen to seduce Makedda's maid. She too had taken water from beside Solomon's bed after waking up in the night, before Makedda, and like her mistress, bore the King a son on her return to Ethiopia. The legends, but not the painted versions, explain that the maid, angry that her son was to be passed over for kingship in favour of Menilek, sent him to Jerusalem to ask Solomon's favour, but because he could not identify the King correctly when he arrived, Solomon disowned him. The maid's son was later said to have founded the Zagwe dynasty of Ethiopian rulers.

The Legend and its Depiction in Ethiopian Art

The legend of Solomon and the Queen of Sheba first became popular in contemporary Ethiopian art in the time of Menilek II, who reigned from 1889 to 1909. By recalling the exploits of the original Menilek, the art emphasized a direct connection between the country's legendary past and its current ruler. The tale also served as a reminder of continued divine favour on Ethiopia, its government, and its people.

In traditional Ethiopian painting, the different scenes are decorated in a bright palette – blue, orange, red – that gives vibrancy to what are essentially stock representations, but vary in the number of scenes depicted (fig. 4). Figures are shown in similar ways, even when painted by different artists. For example, the merchant sailing from Jerusalem to Ethiopia is seen travelling to the right, past the pyramids of Egypt (scene 17 on p. 30

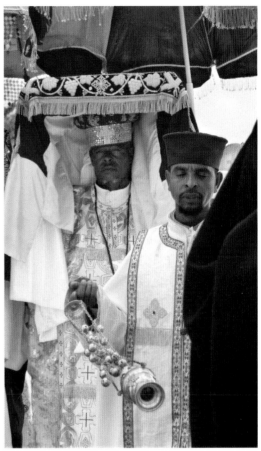

5. Ethiopian priest carrying a *tabot* (an altar slab).

and scene 6 on p. 77). The faces of the different characters have large eyes. Skin tones range from white to dark brown. They generally do not follow a consistent pattern of use, but rather help distinguish between different characters in the story (e.g. scenes 6 and 14 on pp. 19, 27).

Certain iconographic touches make specific reference to particular aspects of Ethiopian culture and society. The Lion beside the Queen of Sheba appears in several panels because the Lion of Judah was a symbol of the Ethiopian royal house (e.g. scenes 18, 23, 47 on pp. 31, 36, 60). Solomon and the Queen dine at a woven *masob* table, traditionally used in Ethiopia for the serving of food (scene 29 on p. 42). The smith whom Solomon presents to Makedda is represented as a horned demon, since by tradition, smiths are thought to cast the "evil eye" and are consequently feared (scene 41 on p. 54). The young Menilek plays *ganna*, a game resembling hockey and still an Ethiopian pastime (scene 17 on p. 88). The bearded figure, presumably a priest, carrying the Ark of the Covenant away from Jerusalem on Menilek's boat (scene 51 on

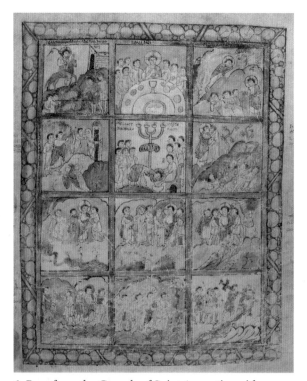

6. Page from the *Gospels of Saint Augustine* with scenes showing the Passion of Christ (Parker Library, Corpus Christi College, Cambridge; MS 286, fol. 125r).

p. 64) resembles a priest of the modern Ethiopian church, holding a cloth-covered *tabot* (an altar slab representing the Ark of the Covenant) above his head (fig. 5). Makedda's tomb has stelai above it (scene 56 on p. 69), resembling those of Aksum, set up in the third and early fourth centuries AD (fig. 9).

The legend is most commonly painted on canvas in forty-four separate scenes, each one separated by decorated strips. Panels conveyed the essence of the narrative to those unable to read the accompanying labels. Although rarely surviving, illustrations divided into separate scenes are also traditional in early Gospel manuscripts of the west, such as on a parchment page showing scenes from the life of Christ to accompany the text of the late sixth-century *Gospels of St Augustine* now in Cambridge, England (fig. 6).

Biblical scenes in registers or rows of framed panels were painted or dyed on linen wall-hangings in Egypt in the third to sixth centuries AD. Such scenes also were depicted on a large scale on wall-paintings in churches and synagogues. The earliest surviving extensive example is in the synagogue at Dura-Europos in Syria (mid-third century AD). Its rows of panels show scenes such as the sacrifice of Abraham's son Isaac, Moses receiving the Law, and the parting of the Red Sea (fig. 7).

Extensive early Christian painted panels survive in the sixth-century Church of Santa Maria Antiqua in Rome. The practice continued in Ethiopia through to the present, with many examples surviving in its churches. In Gondar, for example, at the Debre Berhan Selassie Church ("Trinity Church of the Mountain of Light") built in the nineteenth century, there are panels showing the life of Christ alongside other biblical scenes (fig. 8).

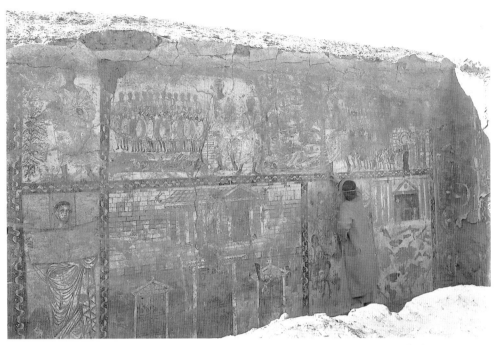

7. West wall of the Synagogue at Dura-Europos, under excavation in 1932, with the archaeologist Susan Hopkins in front.

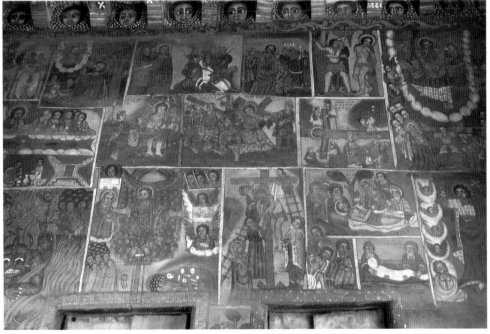

8. Debre Berhan Selassie Church, Gondar, decorated with scenes from the life of Christ.

A Painting of the Legend on Canvas in 56 Scenes

Janbaru Wandemmu, the artist of the Groton painting, painted the legend of Solomon and the Queen of Sheba on a canvas now in a private collection in the United Kingdom. He signed and dated it at the bottom to "the time of Haile Selassie, King of Kings of Ethiopia", without giving an exact year, but he is known to have been active from at least the 1950s. This painting (0.72 x 0.61 m; 28 1/2 by 24 inches) presents the legend in 56 scenes, each one labelled above in Amharic, a modern Ethiopian language. Those individual scenes are presented here, before the ones from the Groton goatskin, since they provide more details of the story.

This canvas is one of the most complete sets of representations for the entire legend of Solomon and the Queen of Sheba. The artist has relied not only on the *Kebra Nagast*, but also on oral tradition. Panels 1 to 15 tell of Agabo and the snake dragon. The legend of Makedda and Solomon follows in panels 16 to 44, which show Solomon's seduction of not only Makedda, but also of her maid. Panels 45 to 52 abbreviate the story of Menilek's return to Jerusalem and his removal of the Ark to Ethiopia. In the final panels, 53 to 56, Makedda dies and Menilek succeeds her as ruler.

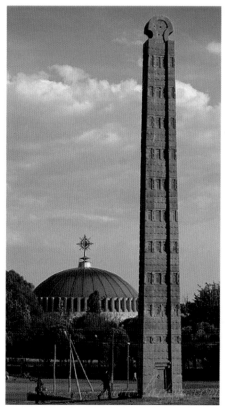

9. Aksum, stele and Cathedral of Maryam Tsion.

The Groton Goatskin

The Groton painting is signed at the top right by Janbaru Wandemmu and undated. It is on parchment, a writing material made from goatskin which is treated, dried, and then stretched. But rather than being cut to size, as for the pages of a book, the whole skin (0.98 m or 32 inches at its greatest length; 0.81 m or 38 1/2 inches at its widest) has been used for the Groton School painting, which is now framed in glass (1.15 x 1.02 m; 45 1/4 x 40 inches).

Even among the many Ethiopian representations of the encounter between Solomon and the Queen, the Groton example is notable. The use of parchment is unusual because it is considerably more expensive than canvas. Also unusual is the depiction of two lions, one facing the other, above the story, both crouched beneath a parasol (p. 71). The lions allude to the Lion of Judah (symbol of the Ethiopian monarchy and Haile Selassie) and the parasol recalls

similar ones carried during Ethiopian Church processions, such as in Jerusalem (fig. 1). Above the lions are two cables that connect one side of the painting to the other, giving the impression of the pediment above a church. The individual scenes are identified by inscriptions written above in Amharic in red or black lettering, but with no discernible pattern for the use of either colour.

The artist has abbreviated the tale considerably, while still using material from the *Kebra Nagast* and other versions of the legend of the Queen of Sheba. Scenes 1 to 5 show Agabo and his poisoning of the snake dragon. Scenes 6 to 10 essentially follow the *Kebra Nagast*, but the inscriptions provide additional detail, identifying Tamrin's gift to Solomon as perfume, one of the products for which Sheba was famous. Scenes 11 to 15 show the events after Solomon's dinner with Makedda and elaborate further by depicting the seduction of Makedda's maid. In scenes 16 to 20, Menilek's story is told, ending with his journey to Jerusalem. The artist has chosen not to show Menilek's meeting with Solomon or his taking of the Ark. In the final five scenes, Menilek gives the Ark to his mother, and after her death, he succeeds her as ruler. The last panel shows Menilek, in front of his mother's tomb, with stelai similar to those at Aksum (fig. 9).

A Note on the Translation

In some captions pronouns (he, she, etc.) have been replaced by the name of the person being mentioned (e.g. Agabo, Makedda). Incomplete words or captions have also been completed for clarity.

Acknowledgements

For their help, we are grateful to Monika Andersson, Lewathan Asrat, Sir Brian and Lady Barder, Carlotta Barranu, Alessandro Bausi, Elisabeth Biasio, Douglas Brown, the Master and Fellows of Corpus Christi College, Cambridge, Megan Doyon, Michael Gervers, Joseph Greene, John Jacobs, Solomon Kibriye, John MacEachern, Temba Maqubela, Judith McKenzie, Charlotte Mellgard, Steve Miner, Mai Musié, William Polk, Elisabetta Povoledo, Hope Prockop, Marlena Whiting, Miranda Williams, Sean Winslow, and the Buildings and Grounds Department and the Dillon Fund of Groton School.

Image credits

Cover image: Hanna Kim.
Figures: 1 Emilio Bonfiglio/Manar al-Athar; 2–3 Michael Gervers; 4 Miranda Williams; 5, 9 Sean Winslow; 6 The Master and Fellows of Corpus Christi College, Cambridge; 7 Yale University Art Gallery (Dura-Europos Collection); 8 Andrew Holt/Alamy.
Photographs on pages: 12–69 Miranda Williams; 70–96 Hanna Kim.

Numbered panels of the 56-scene painting.

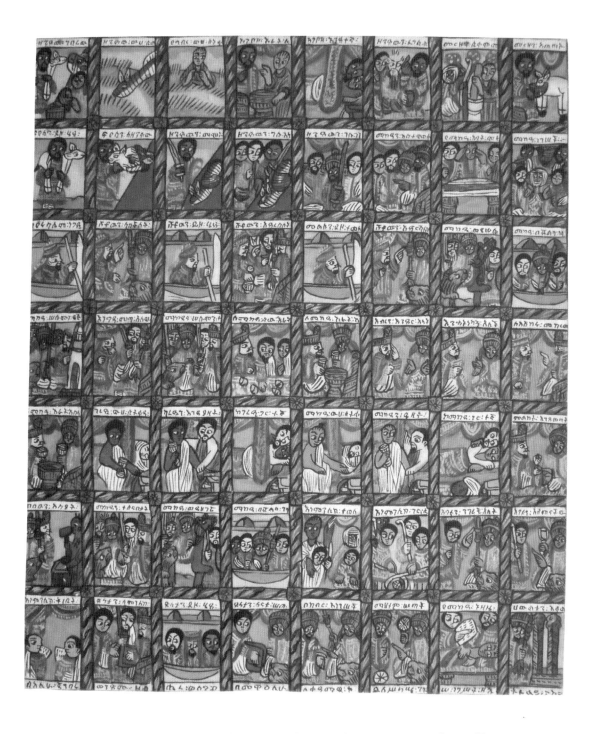

Artist: Janbaru Wandemmu from the region of Wollega, in the time of Haile Selassie I, King of Kings of Ethiopia.

Inscribed on the bottom line.

1. Agabo pays tribute (tax) to the snake dragon.

2. The snake dragon gives him the water.

3. The taxed water.

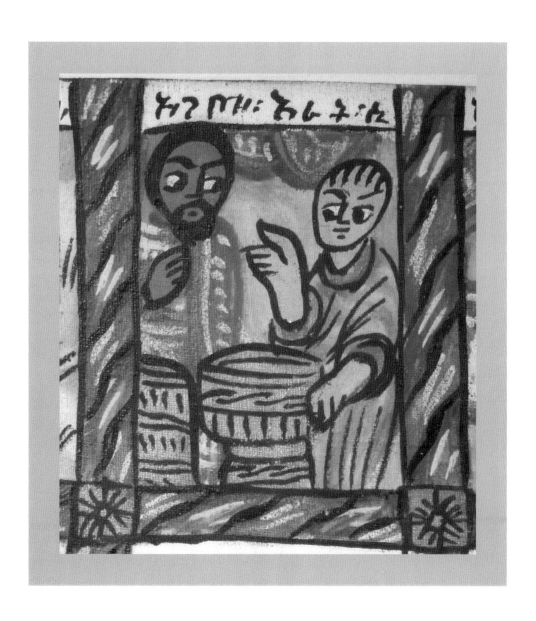

4. Agabo at dinner.

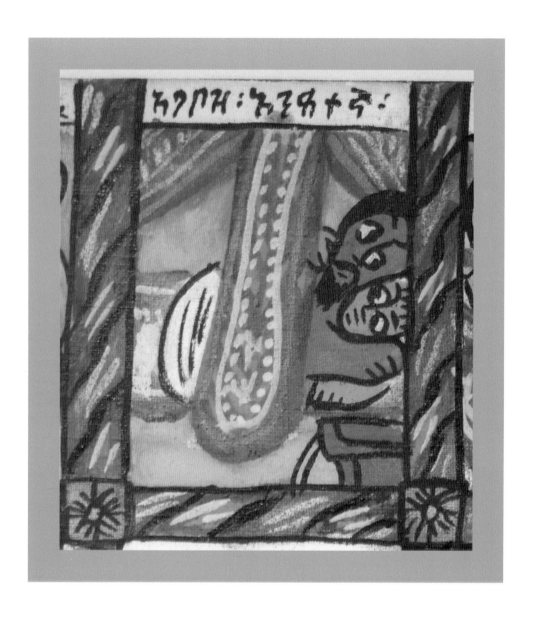

5. Agabo in bed.

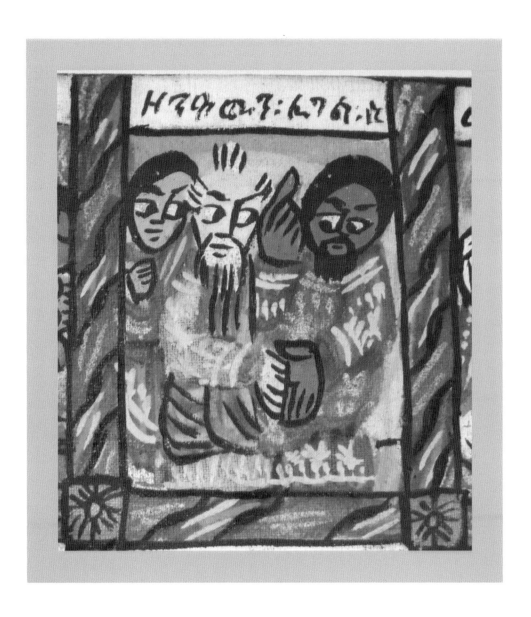

6. Agabo wants to kill the snake dragon.

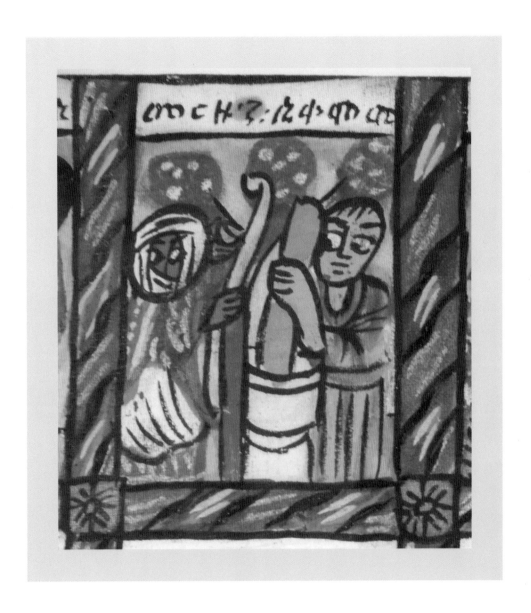

7. They grind and mix the poison.

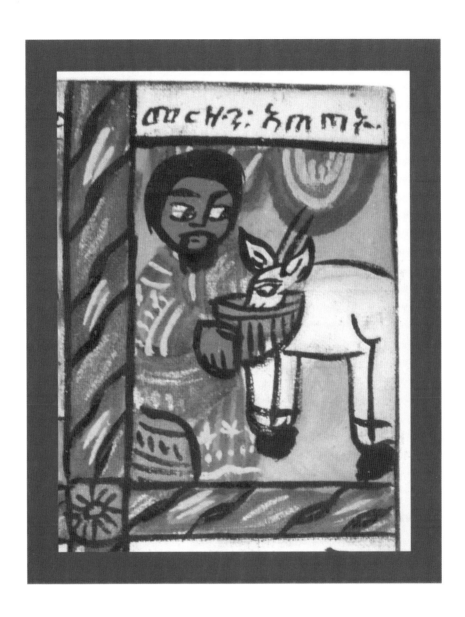

8. Agabo gives the goat the poison to drink.

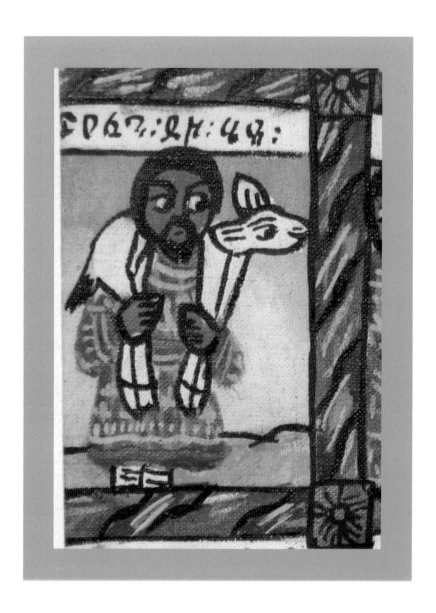

9. Agabo takes the goat with him.

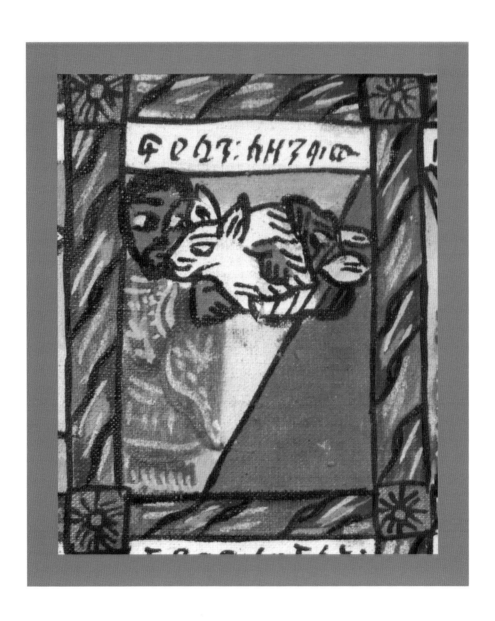

10. He gives the goat to the snake dragon.

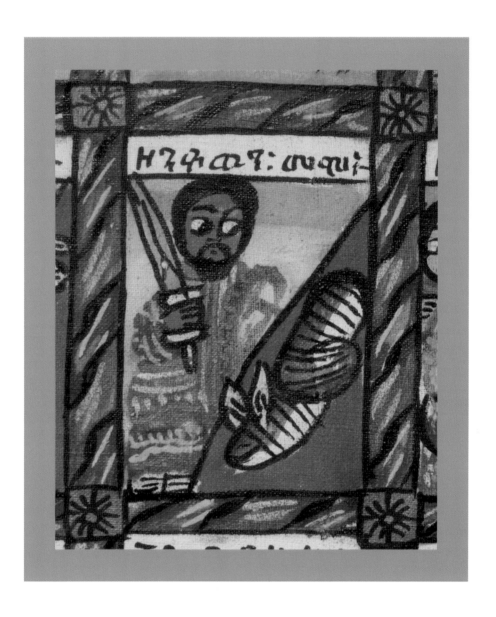

11. The snake dragon dies.

He is killed by the poison in the goat.

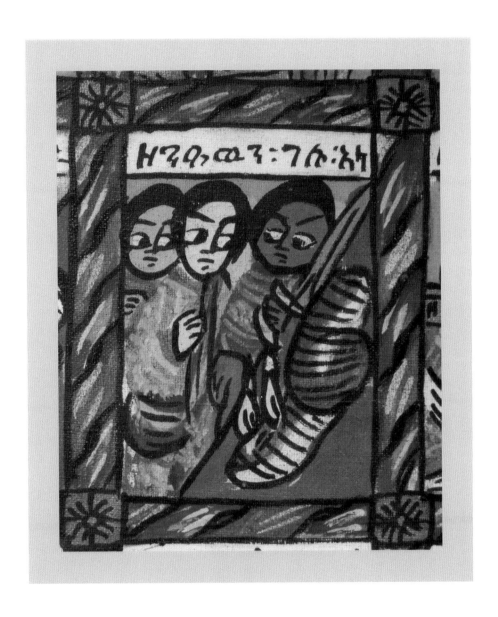

12. Agabo has killed the snake dragon.

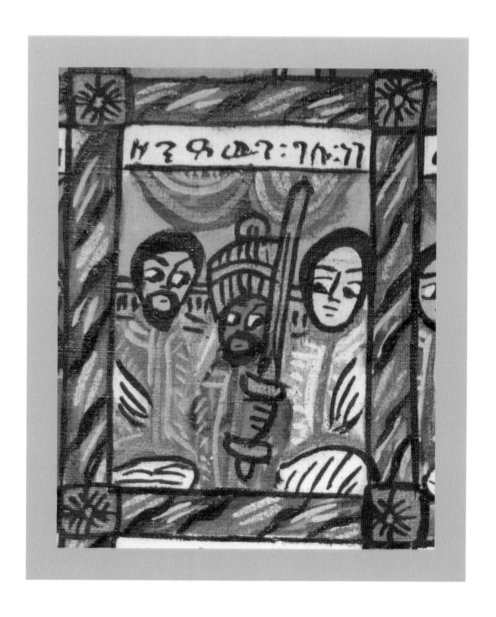

13. Having killed the snake dragon, Agabo becomes king.

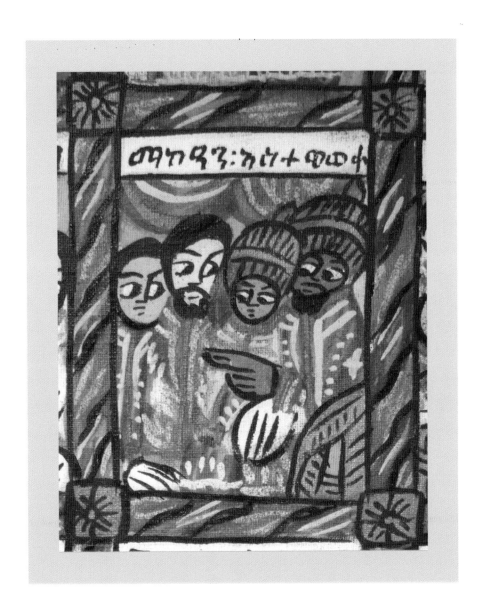

14. He introduces Makedda.

She is Agabo's daughter.

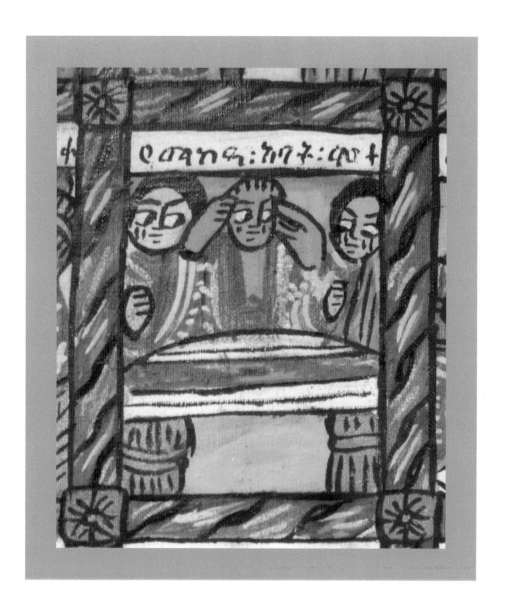

15. Agabo, the father of Makedda, dies.

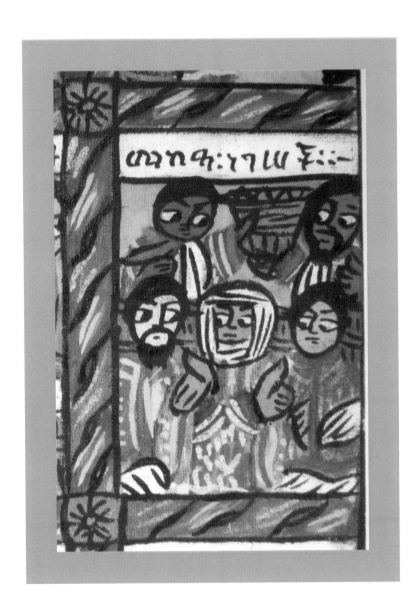

16. Makedda becomes queen.

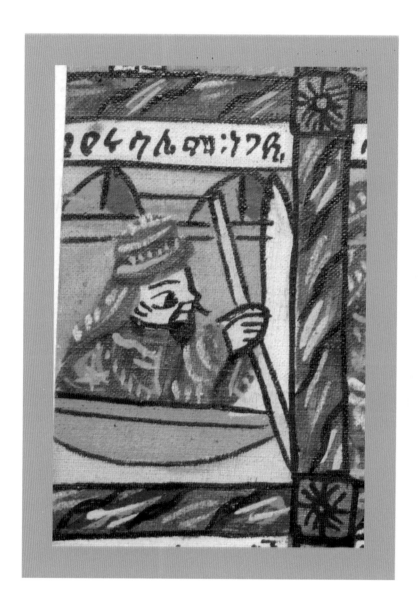

17. A merchant of Jerusalem.

He is sailing to Ethiopia past the pyramids of Egypt.

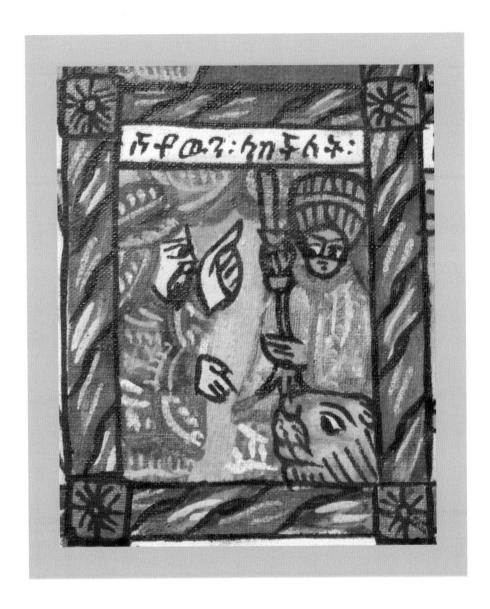

18. Makedda sends Solomon perfume.

The lion was the symbol of the Ethiopian monarchy
under Haile Selassie, when this painting was done.

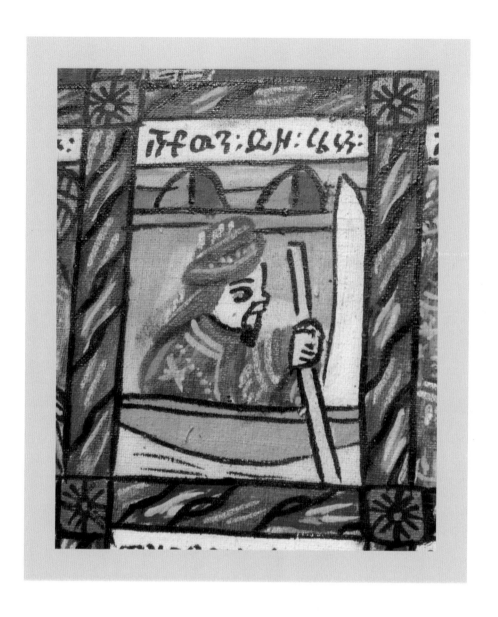

19. The merchant took the perfume and left.

He sails past the pyramids of Egypt on the way back to Jerusalem.

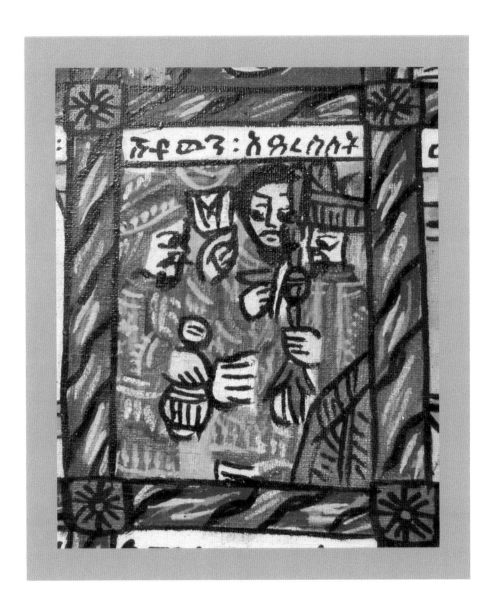

20. He delivers the perfume to Solomon.

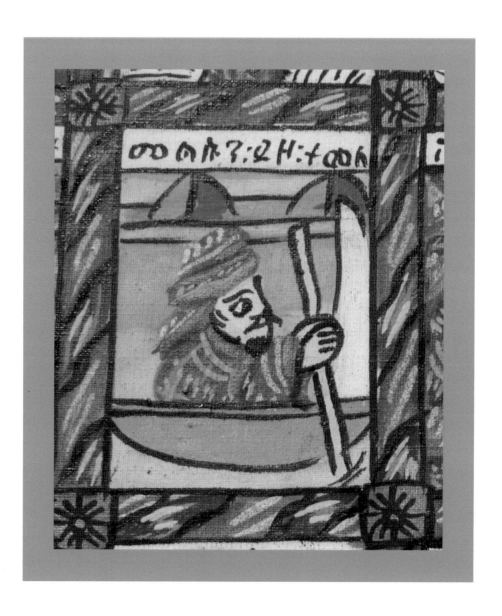

21. The merchant travels back with a reply.

He sails back to Ethiopia.

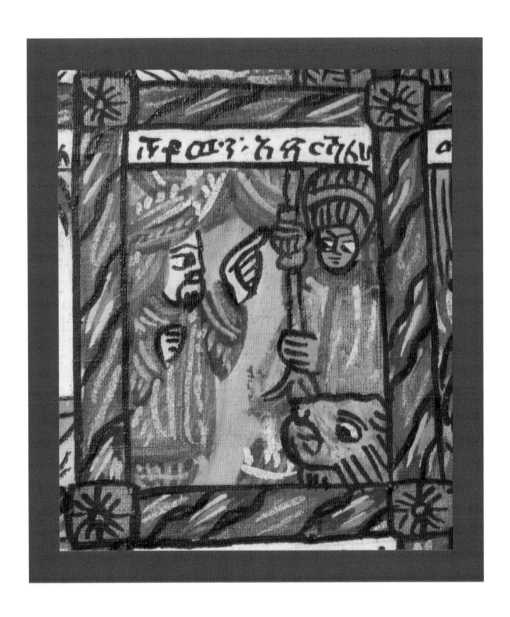

22. He tells Makedda, "I have delivered the perfume".

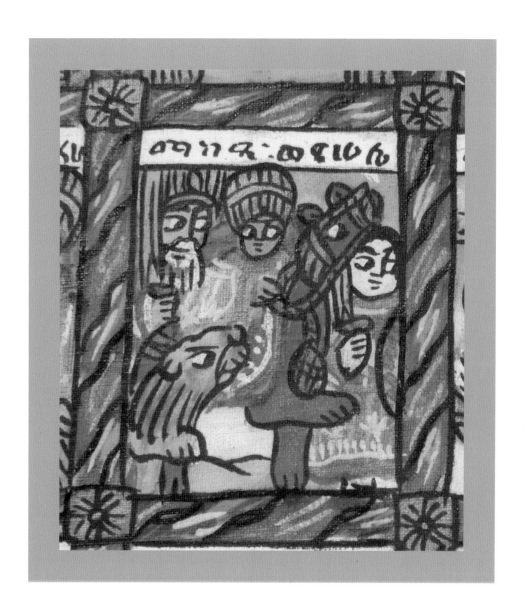

23. Makedda on her way to Solomon.

First she travels overland on a camel.

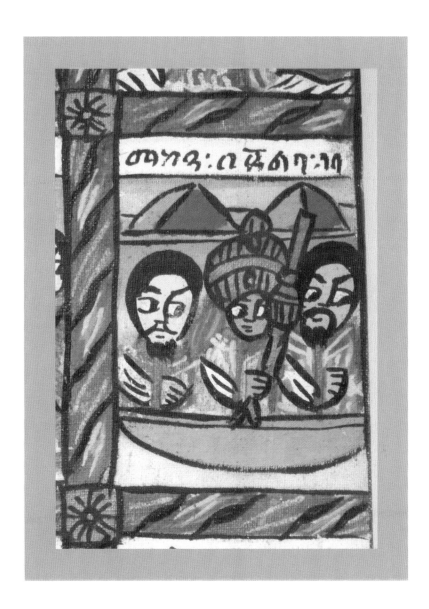

24. Makedda sails in a boat.

She sails past the pyramids of Egypt.

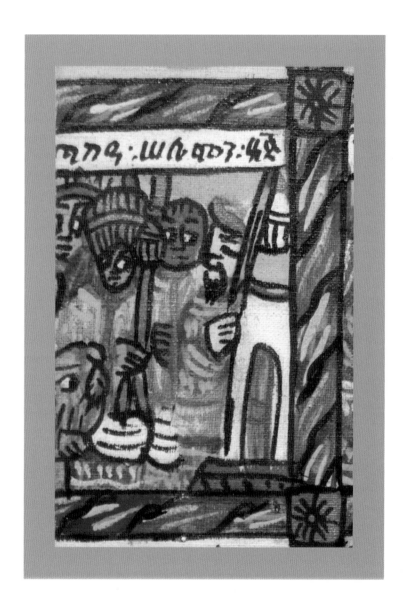

25. Makedda at Solomon's door.

26. His servant tells Solomon, "A guest has arrived".

27. Makedda and Solomon.

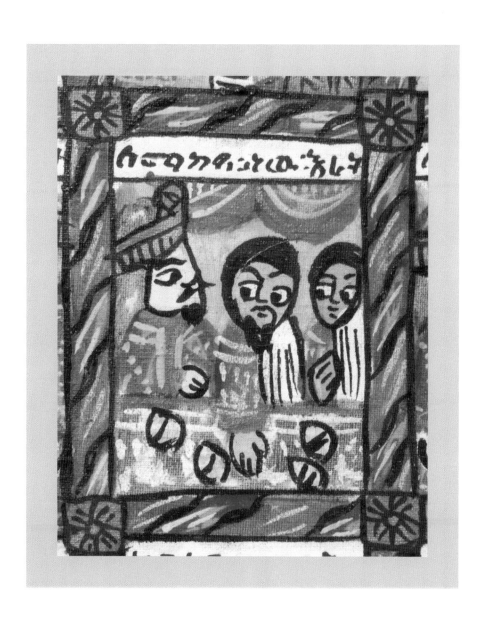

28. Solomon tells his servants,
"This dinner is for Makedda".

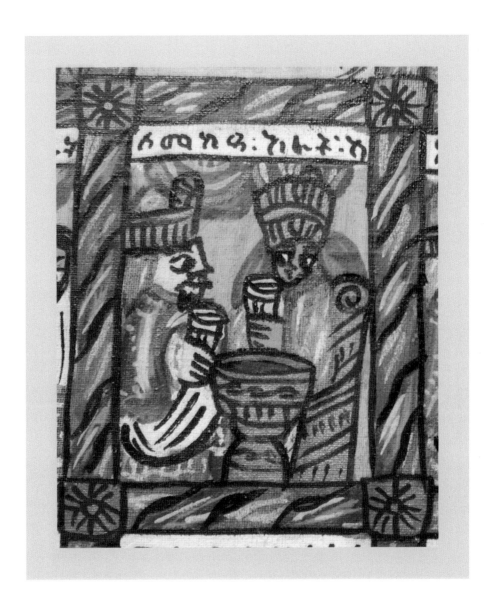

29. The dinner for Makedda.

Even though they are in Jerusalem, the dinner is depicted
served on a small woven table, a *masob* in Amharic,
traditionally used in Ethiopia for serving food.

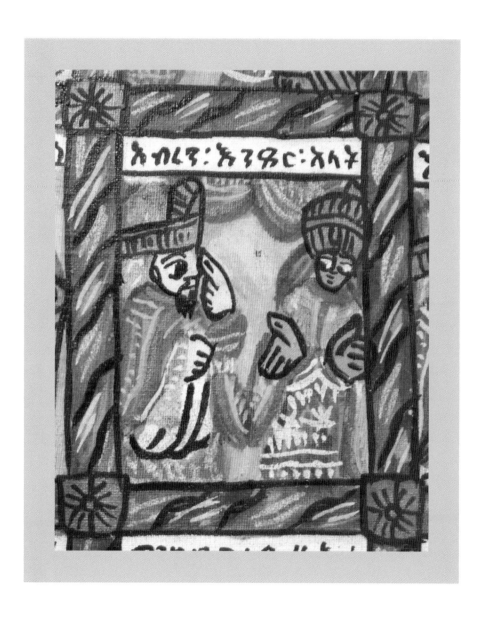

30. Solomon says to Makedda,
"Let us spend the night together".

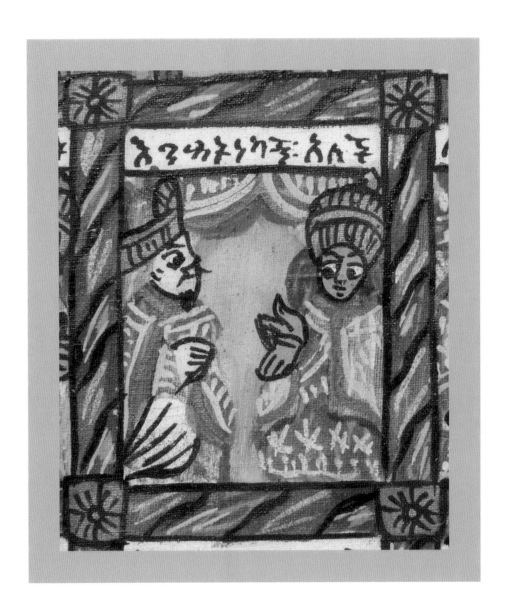

31. Makedda says to him, "Do not touch me".

Solomon replies that he will not sleep with her
as long as she takes nothing of his.

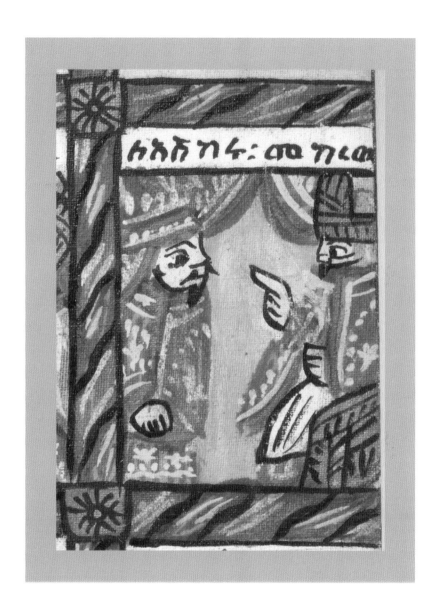

32. Solomon gives instructions to his servant.

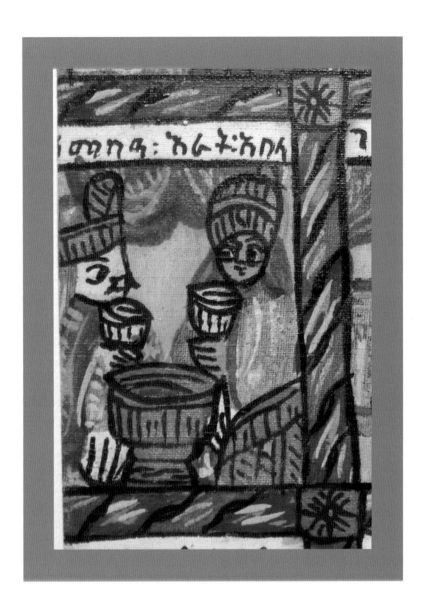

33. Solomon treats Makedda to dinner.

The dinner is very spicy and salty.

34. As Makedda's maid pours water,

Makedda's maid is thirsty because of the spicy and salty dinner.

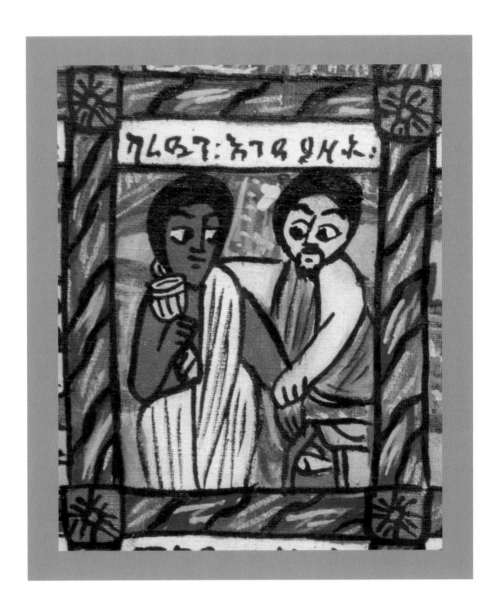

35. Solomon seizes the maid.

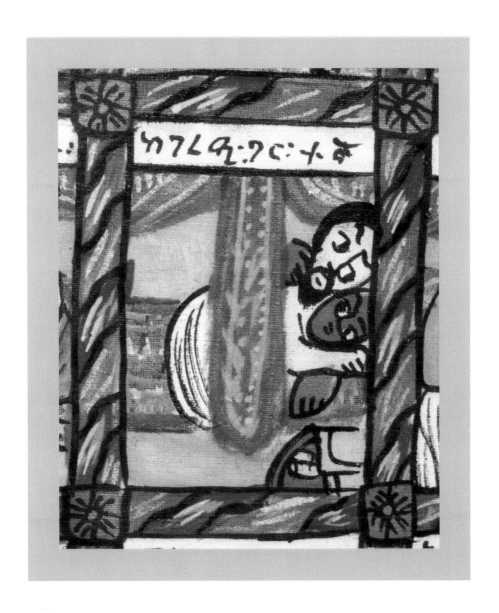

36. Solomon sleeps with the maid.

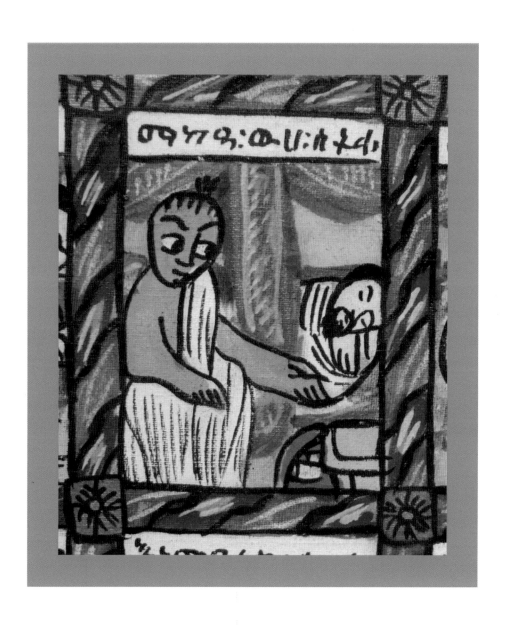

37. As Makedda pours water,

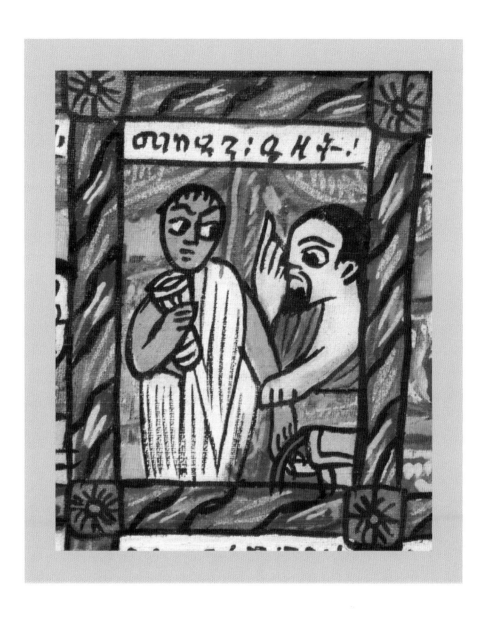

38. Solomon seizes Makedda.

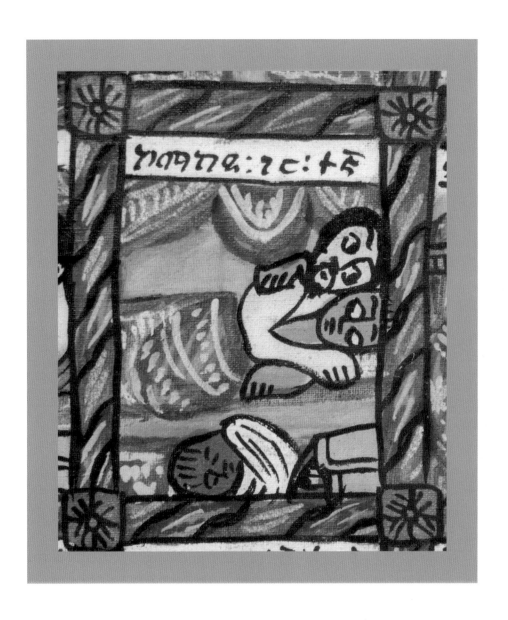

39. Solomon sleeps with Makedda.

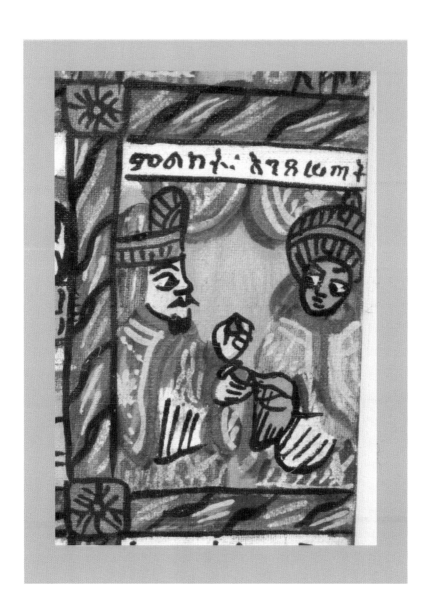

40. Solomon gives Makedda a sign (a clue).

He gives her a sign (a ring) so that he will recognize his son.

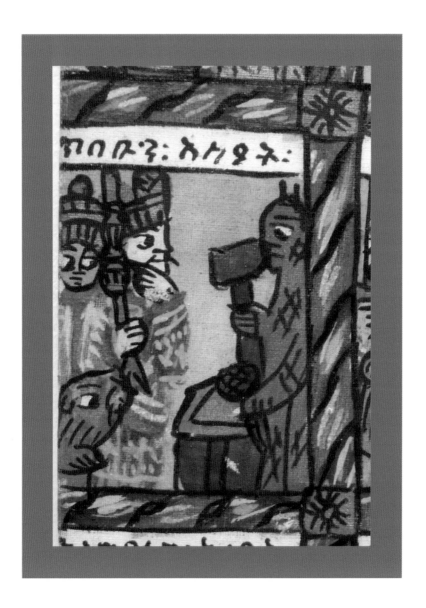

41. Solomon shows Makedda his wisdom (craft).

Solomon is showing a demon demonstrating metalwork.

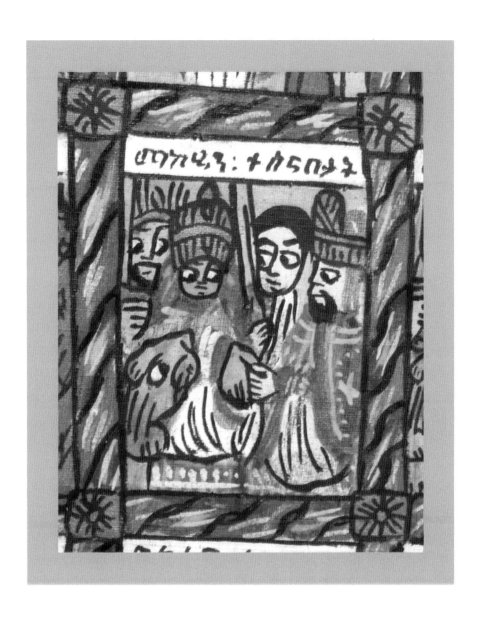

42. Solomon bids Makedda farewell.

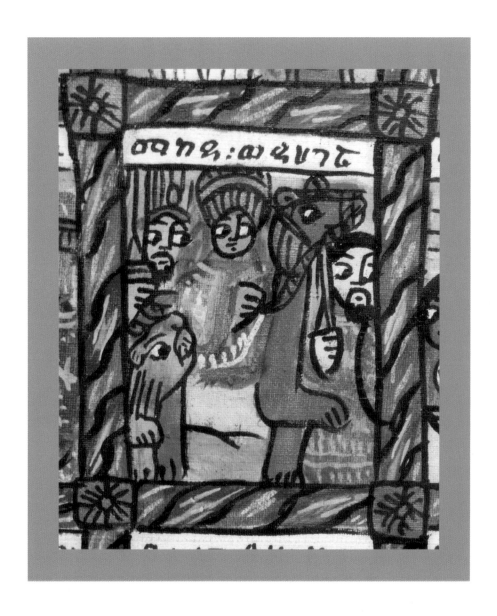

43. Makedda on her way to her country.

First she travels back overland on a camel.

44. Makedda sails in a boat.

She sails past the pyramids of Egypt.

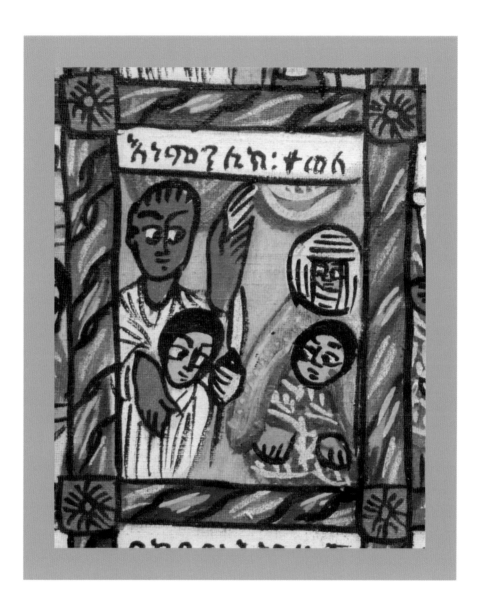

45. Menilek and the son of Makedda's maid are born.

Menilek is Makedda's son.

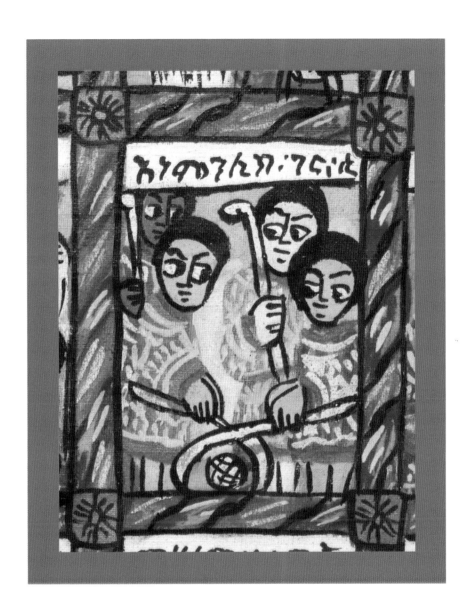

46. Menilek and the maid's son playing *ganna*.

Ganna is a traditional Ethiopian game, similar to field hockey,
played during the Christmas season.

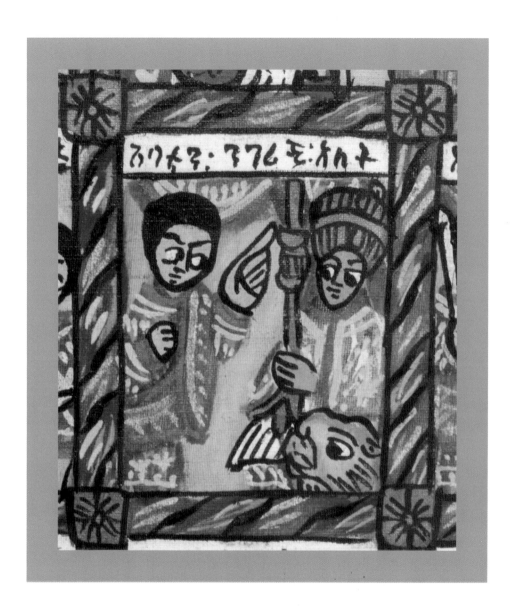

47. Menilek asks Makedda, "Tell me who my father is".

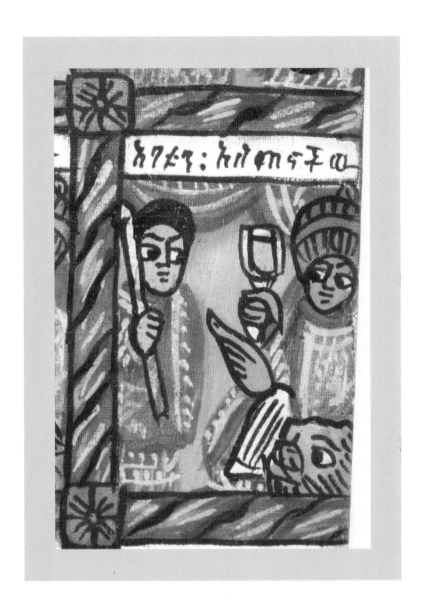

48. Makedda teaches him about his father.

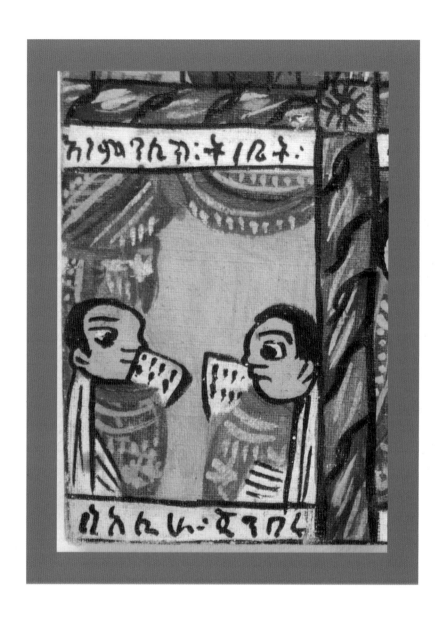

49. Menilek and others at school.

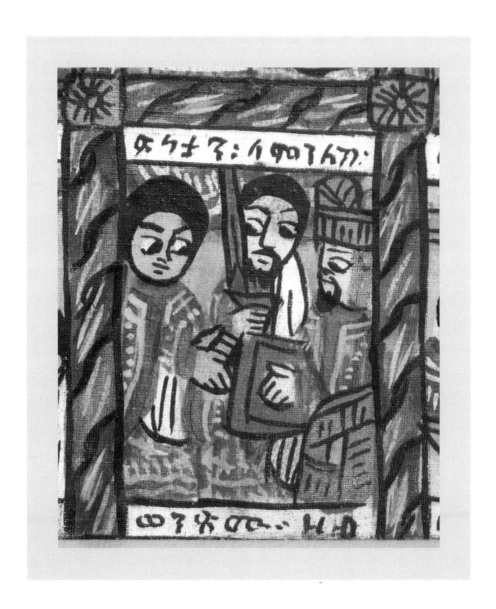

50. Tablet for Menilek.

The Geʿez and Amharic word *tsellat*, meaning "tablets," specifically refers to the tab-
lets containing the Ten Commandments which were kept in the Ark of the Covenant.
The picture shows Solomon giving Menilek the tablets, as tradition has it that
Menilek brought the Ark of the Covenant from Jerusalem to Ethiopia.

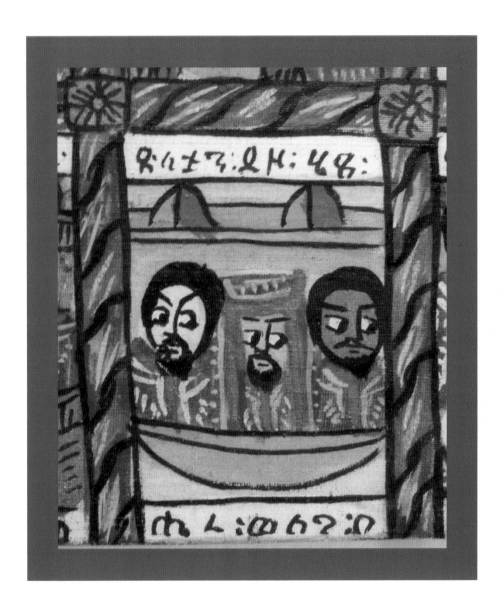

51. Menilek takes the tablet and leaves.

The person in the middle is a priest carrying the tablet covered in cloth
on his head. In the Ethiopian Church the senior priest carries the altar slab
(*tabot*), covered in cloth, on his head during religious processions.
The altar slab represents the Ark of the Covenant.

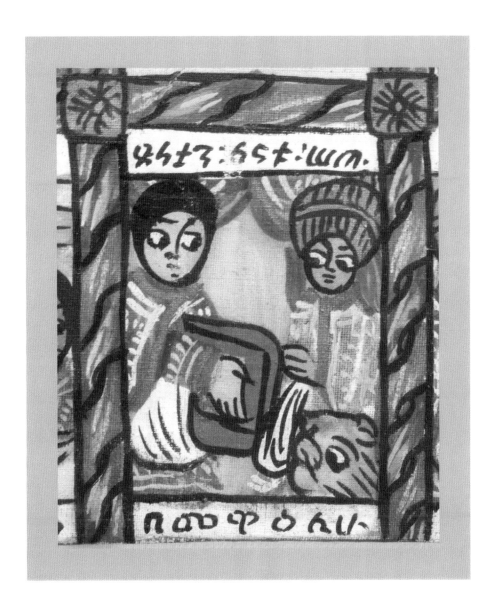

52. Menilek gives the tablet to his mother.

According to Ethiopian tradition, the Ark of the Covenant was placed
in the Cathedral of Mary of Zion (Maryam Tsion) in Aksum,
and is now in the chapel beside the cathedral.

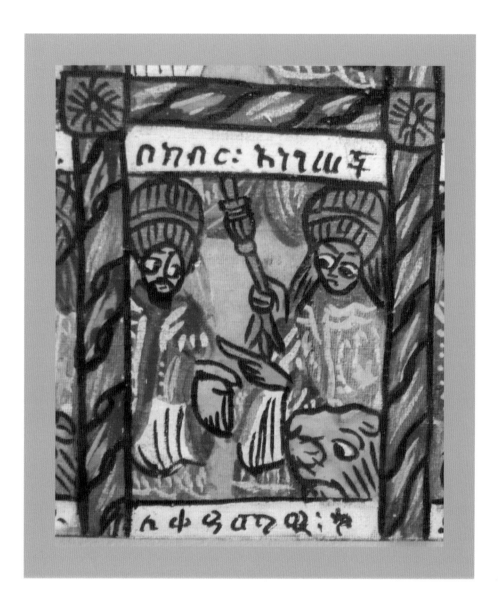

53. Makedda crowns Menilek in glory.

The word for "glory" here is *kebr* – the same as the one in *Kebra Nagast*, or "The Glory of Kings". Menilek is wearing a crown.

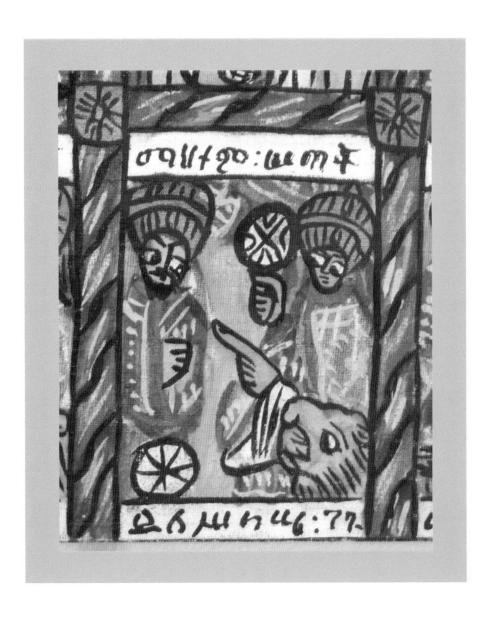

54. Makedda gives Menilek the royal seal.

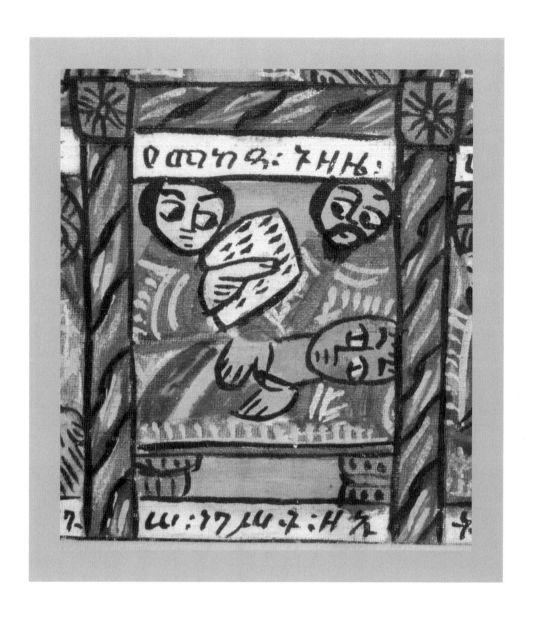

55. Makedda's will is made.

She is on her deathbed.

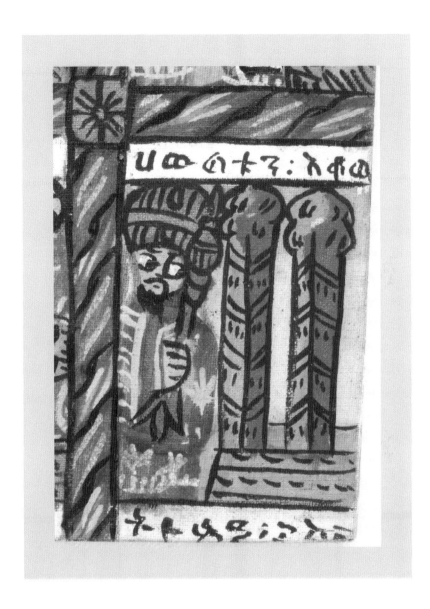

56. Menilek erects monuments.

The monuments depicted are the stelai at Aksum,
with their distinctive tops.

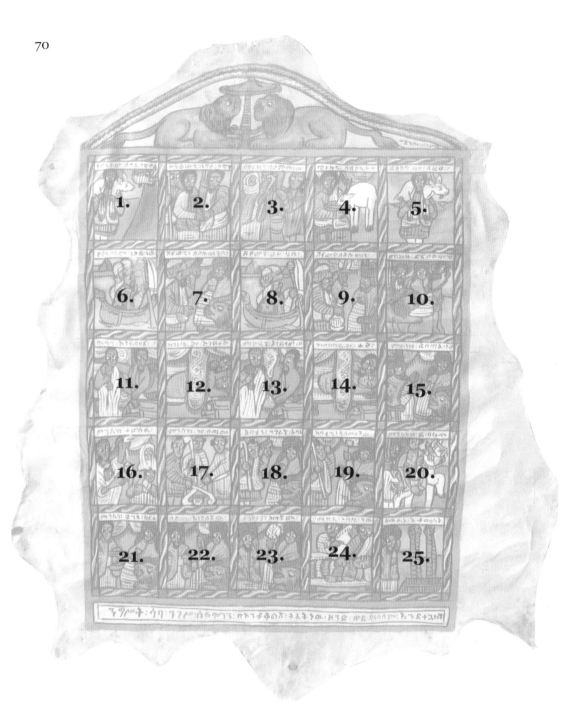

Numbered panels of the Groton Goatskin.

Signed on the top right by Janbaru Wandemmu.

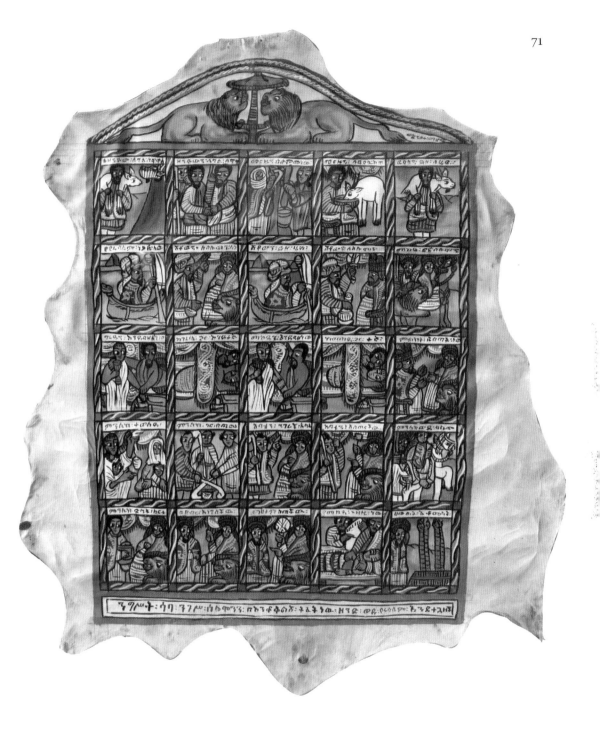

How the Queen of Sheba ("Queen Saba" in Amharic) travelled
to Jerusalem in order to test King Solomon with riddles.

Inscribed on the bottom line.

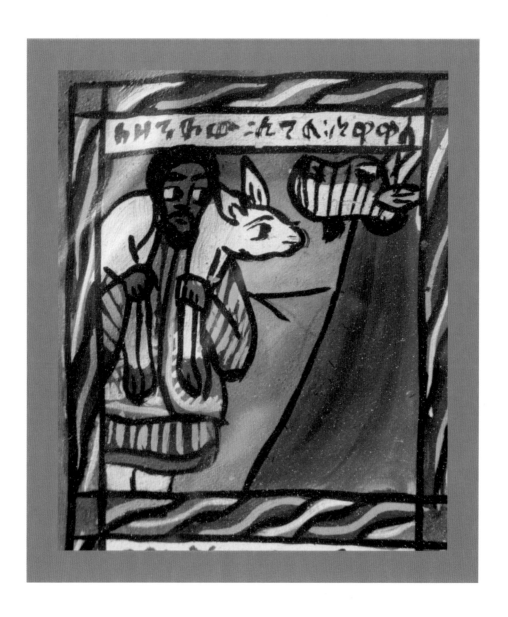

1. Agabo gives the sacrifice in order to kill the snake dragon.

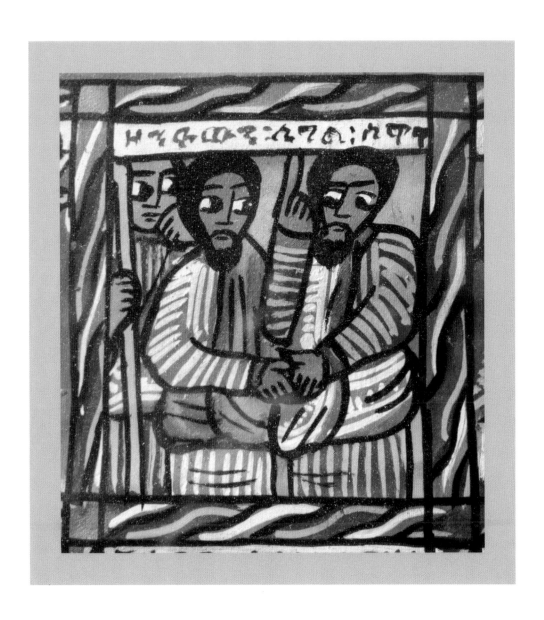

2. He gives the sacrifice in order to kill the snake dragon.

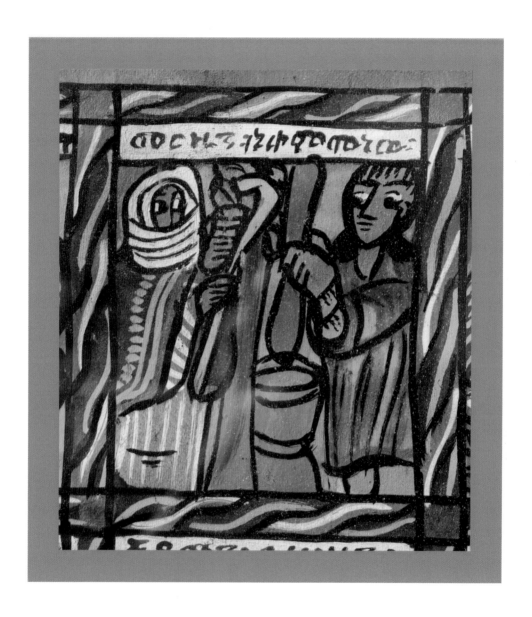

3. They grind and mix the poison.

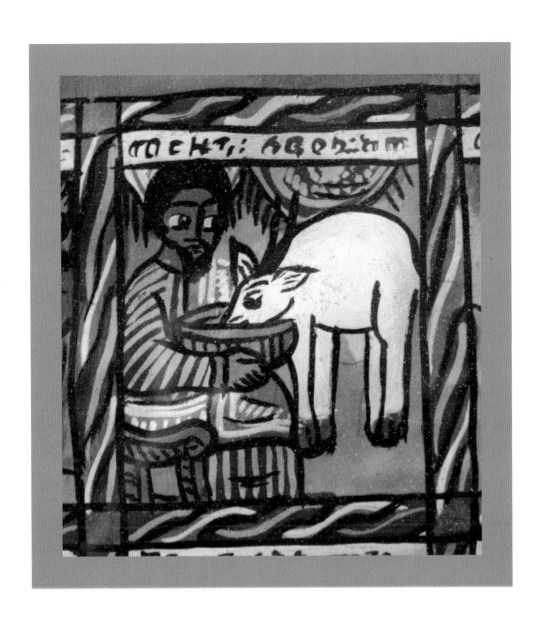

4. He gives the poison to the goat.

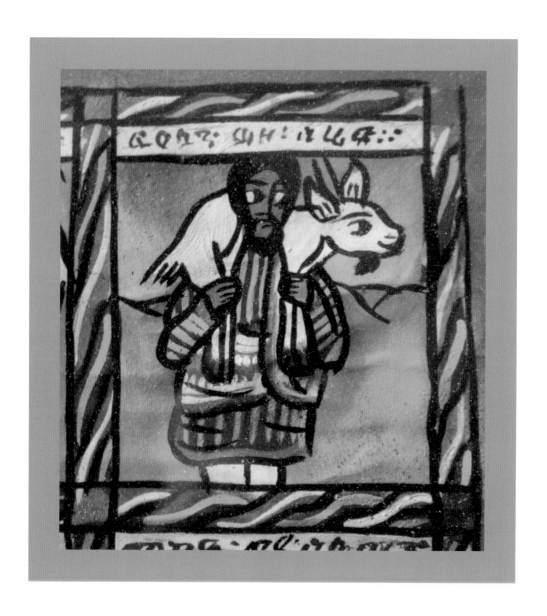

5. He takes the goat with him.

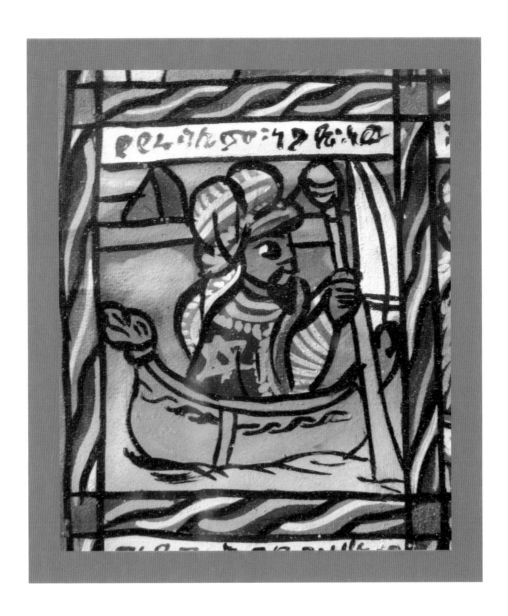

6. A merchant of Jerusalem.

The merchant is sailing to Ethiopia past the pyramids of Egypt.
He has a Star of David on his cloak.

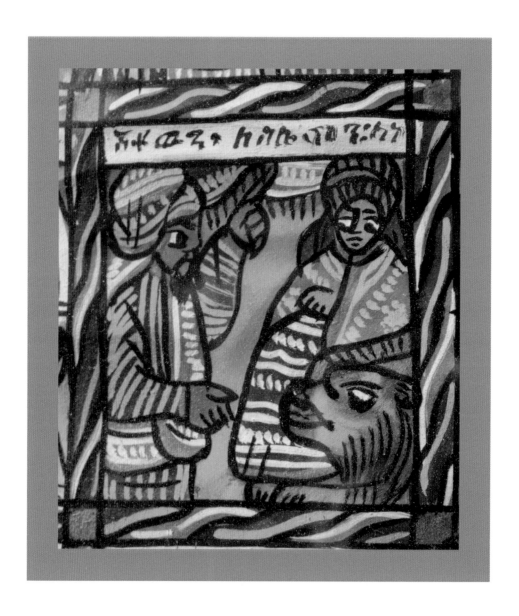

7. Makedda sends perfume to Solomon.

The lion, as in the top panel of this painting, was the symbol of the Ethiopian monarchy.

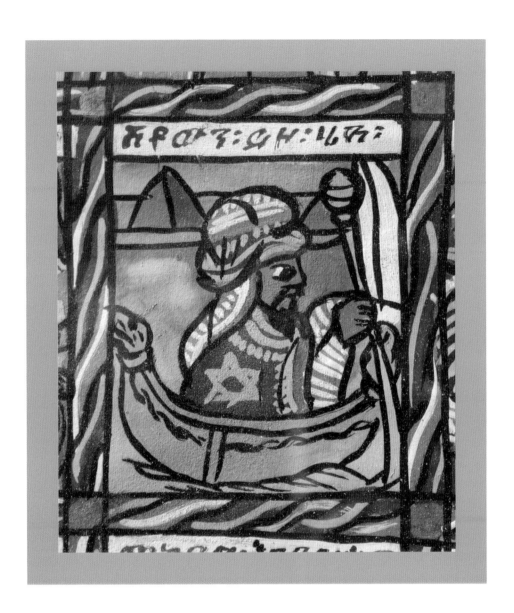

8. The merchant takes the perfume and leaves.

He travels back to Jersualem past the pyramids of Egypt.

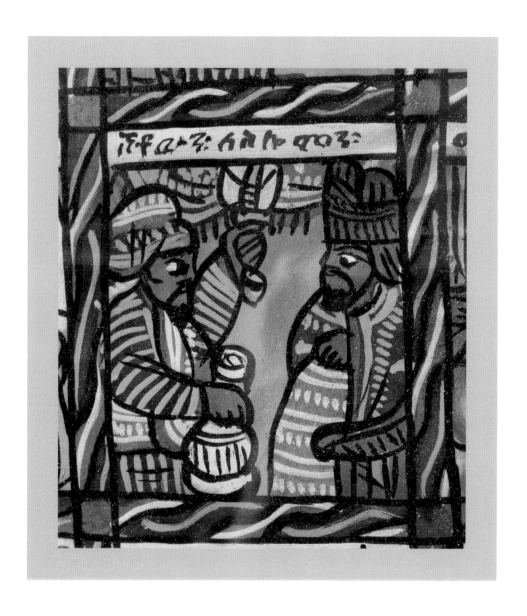

9. He gives the perfume to Solomon.

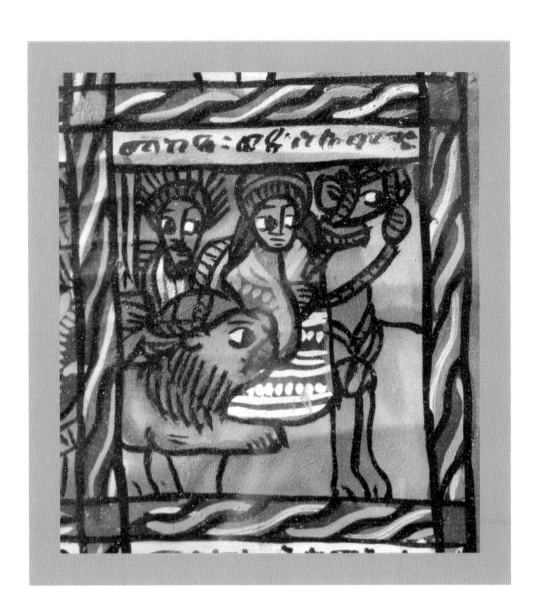

10. Makedda on her way to Solomon.

She is riding a camel.

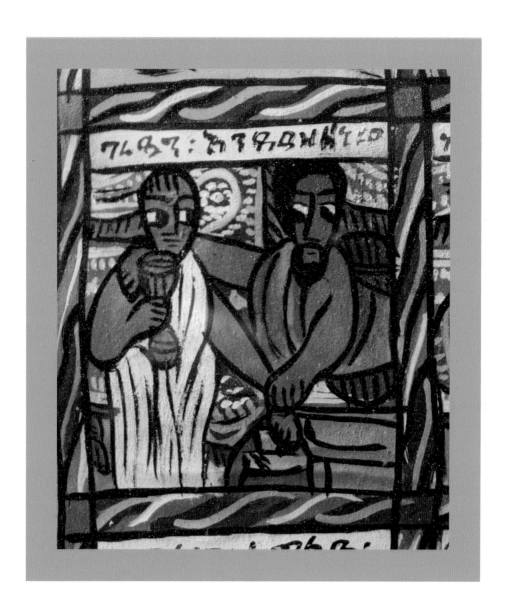

11. Solomon seizes Makedda's maid.

The painting does not depict Makedda's arrival in Jerusalem
or her dinner with Solomon. The maid is depicted here
drinking water because the dinner was salty and spicy.

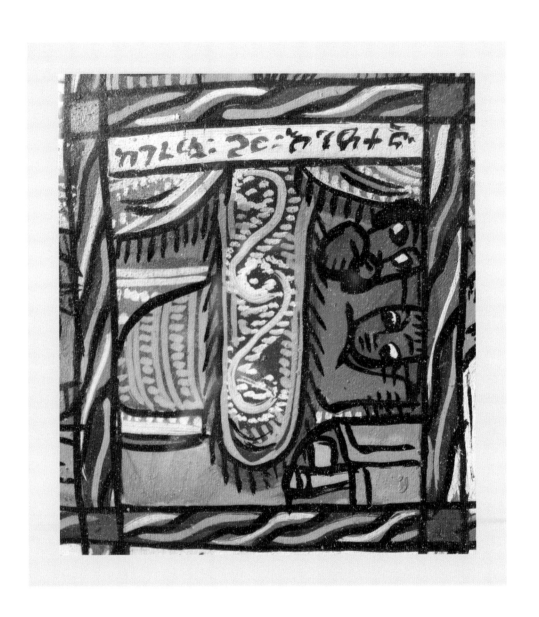

12. Solomon sleeps with Makedda's maid.

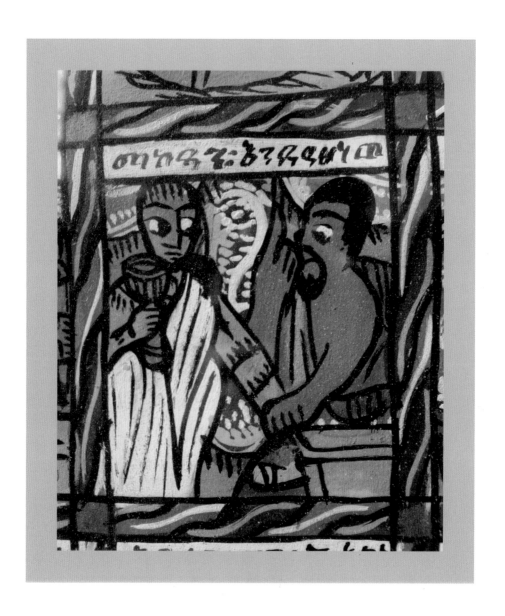

13. Solomon seizes Makedda.

Makedda is depicted drinking water too.

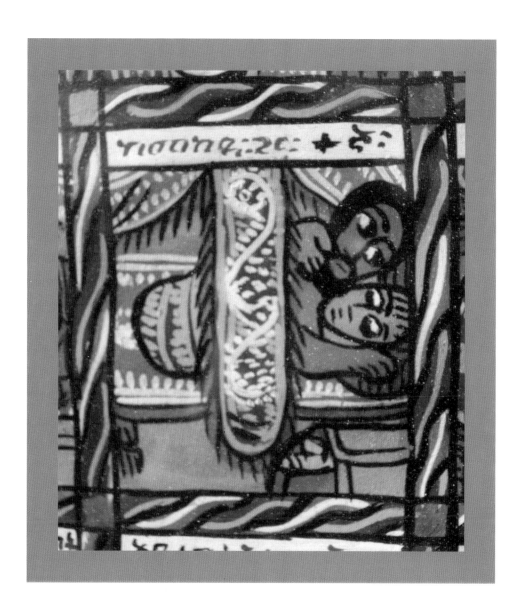

14. Solomon sleeps with Makedda.

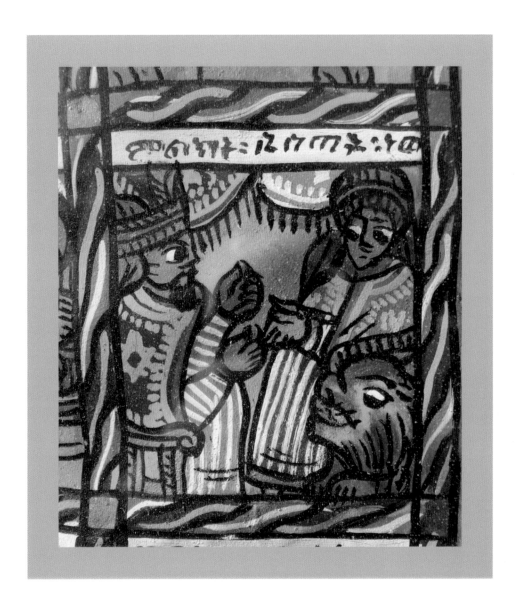

15. Solomon gives Makedda a sign (piece of a clue).

Solomon's cloak has a Star of David on it.

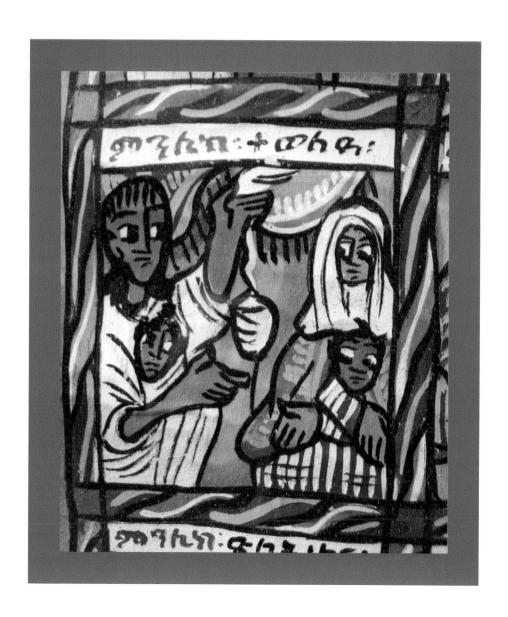

16. Her son Menilek is born.

The maid's son is also born.

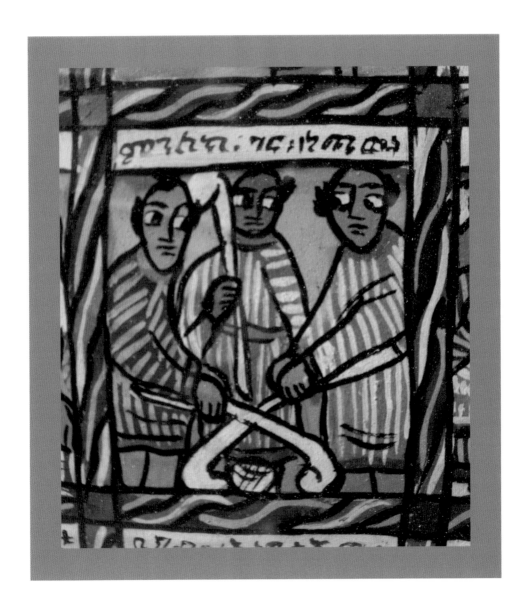

17. Menilek playing the game of *ganna*.

Ganna is a traditional Ethiopian game, similar to field hockey,
played during the Christmas season.

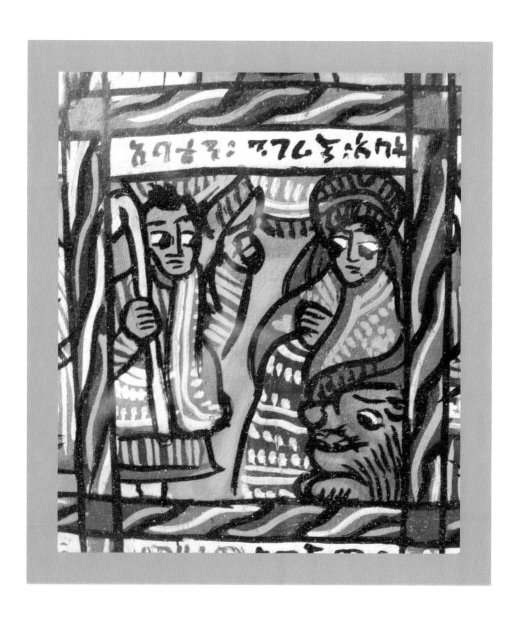

18. Menilek asks Makedda, "Tell me who my father is".

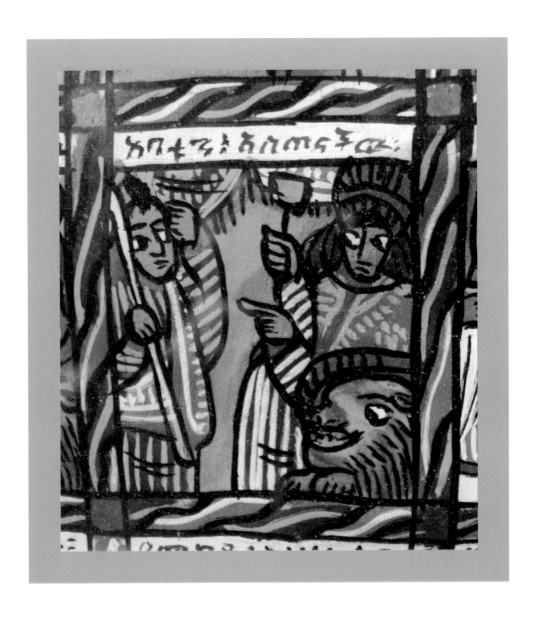

19. Makedda teaches him about his father.

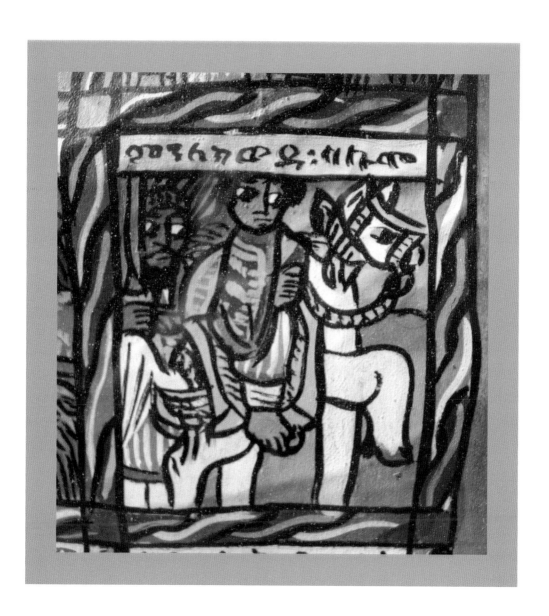

20. Menilek on his way to Solomon.

He is riding on a white horse.

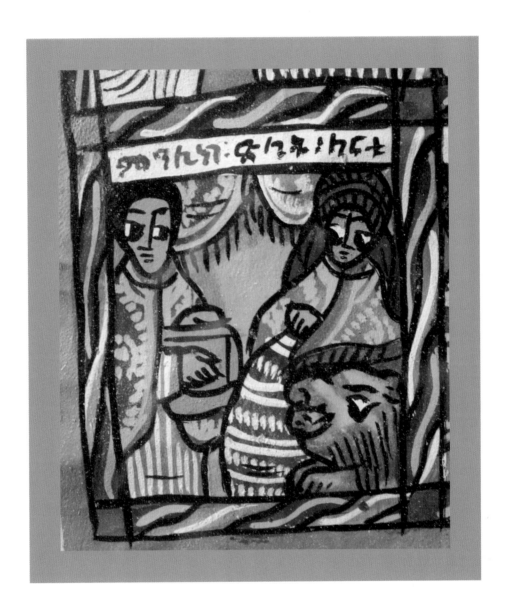

21. Menilek gives the tablet to his mother.

The painting does not depict Menilek's arrival in Jerusalem,
his meeting with Solomon, or his return trip to Ethiopia.

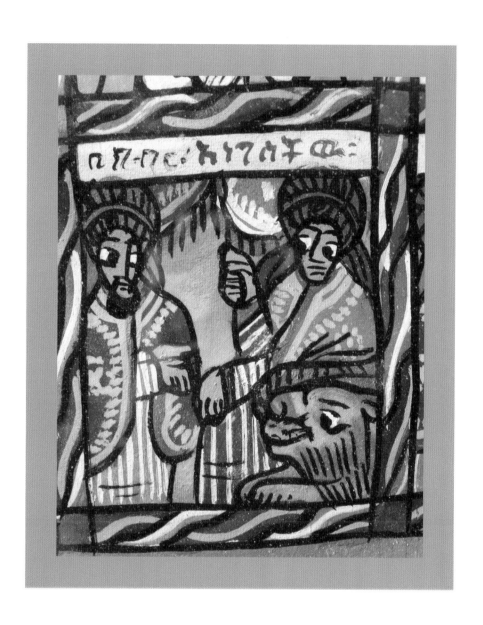

22. Makedda crowns Menilek in glory.

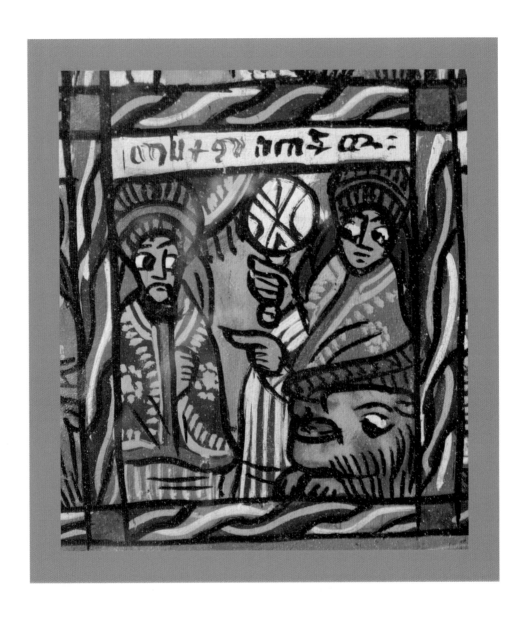

23. Makedda gives Menilek the royal seal.

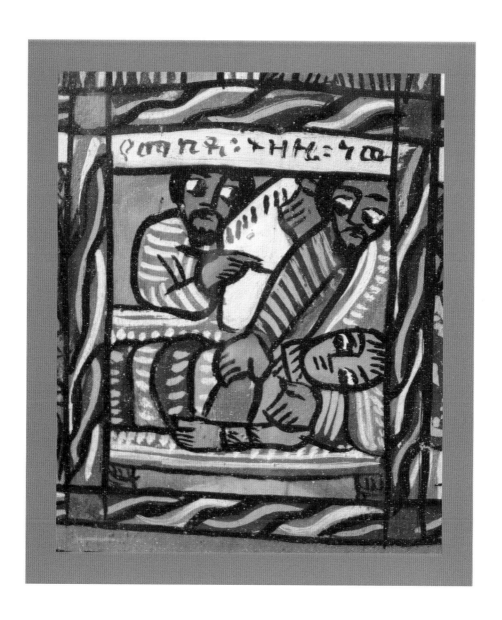

24. Makedda makes her will.

She is on her deathbed.

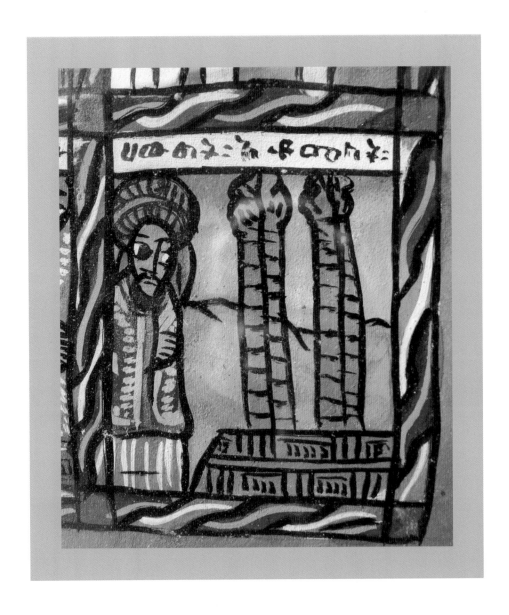

25. Menilek sets up monuments for Makedda.

The monuments depicted are the stelai of Aksum.